D.W. GRIFFITH: AMERICAN FILM MASTER

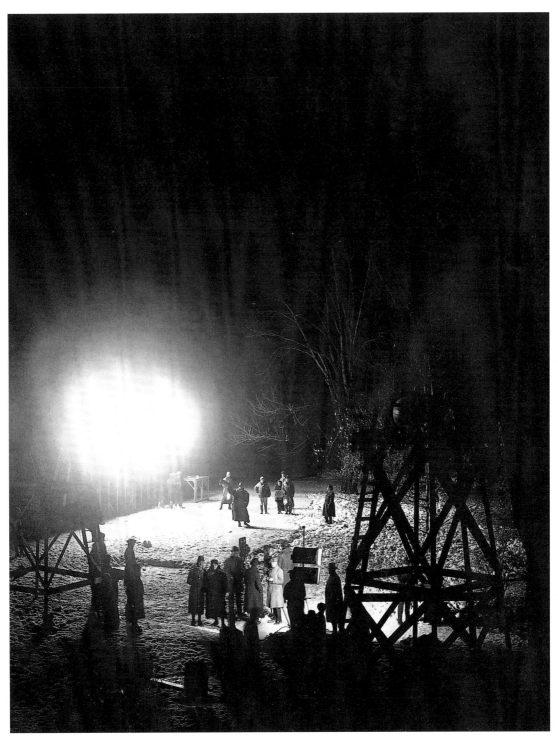

Shooting night scenes in the snow at Mamaroneck, New York, for WAY DOWN EAST, 1920.

D. W. GRIFFITH

AMERICAN FILM MASTER

BY IRIS BARRY

MUSEUM OF MODERN ART FILM LIBRARY SERIES NO. 1

NEW YORK
THE MUSEUM OF MODERN ART

© 1940 by The Museum of Modern Art, New York.
All rights reserved.
Facsimile edition © 2002 by The Museum of Modern Art, 11 West 53 Street, New York, New York 10019
www.moma.org
Library of Congress Control Number 2002109007
ISBN 0-87070-683-7
Electronic typography by Christina Grillo and Gina Rossi
Production by Christina Grillo
Printed and bound by Editoriale Bortolazzi-Stei, s.r.l., Verona
Printed on 135 gsm Gardamat
Distributed in the United States and Canada by
D.A.P. / Distributed Art Publishers, Inc., New York
Printed in Italy

ACKNOWLEDGMENTS

The President and Trustees of the Museum of Modern Art wish to thank those who have lent to the exhibition and, in addition, those who have generously rendered assistance: Mr. and Mrs. David Wark Griffith; Mr. W. R. Oglesby; Miss Anita Loos and Metro-Goldwyn-Mayer Studios; Mr. William D. Kelly of Loew's, Incorporated; Mr. George Freedley, Curator of the Theatre Collection of the New York Public Library; Miss Eleanor O'Donohue of *Photoplay;* Mr. Bayless Hardin of the Kentucky State Historical Society; Mr. Barry Bingham, Mrs. Eugene Howard Ray, Mrs. Ahrens Burgess, Mr. Boyd Martin, Mrs. Churchill Humphrey and Miss Emma Loving for their help in Louisville; Mr and Mrs. Reuben Taylor of Bagdad, Kentucky; Mr. David C. Mearns, Superintendent of the Reading Rooms of the Library of Congress; Mr. Terry Ramsaye, Editor of the *Motion Picture Herald;* Mr. Jay Leyda, former assistant to the Curator of the Film Library; and, in particular, Mr. Alan E. Freedman of DeLuxe Laboratories, who generously provided special facilities for the difficult and time-consuming work of printing early Biograph films.

CONTENTS

PLATES MARKED F. ARE ENLARGEMENTS FROM FILMS;
ALL OTHERS ARE FROM STILLS

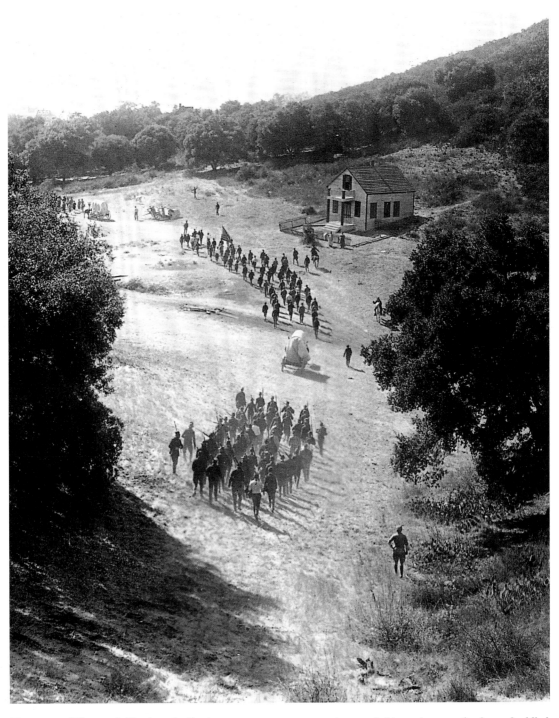

This scene of Sherman's March to the Sea in THE BIRTH OF A NATION is preceded by a close-up of refugees huddled on a hilltop. The camera then moves slowly to the right and irises out to this vast and impressive panorama beyond.

Longshots such as these, used in juxtaposition to closer views, brought psychological as well as visual breadth to this great film, which first fully revealed the power of the motion picture camera and the vast technical resources which Griffith himself had developed.

D.W. GRIFFITH: AMERICAN FILM MASTER

When Fanny Ward returned to the stage in 1907, she first appeared in James K. Hackett's Washington production of *A Fool and a Girl*, a short-lived play by David Wark Griffith, an almost unknown author who was destined for world fame within the next decade, though in another medium. The *New York Telegraph*, reporting next day on this drama of San Francisco low life and the California hop fields, mentioned that the playwright had some reputation as a short-story writer. He had published a free-verse poem in *Leslie's Weekly* a few months before. The previous May in Boston, upon the occasion of his first marriage, he had described himself as thirty years old, a writer by profession, and a resident of Louisville, Kentucky.

By 1907, however, a career of ten years as an actor already lay behind him. It had been followed under a pseudonym. Though as a writer he signed his full and proper name, he apparently felt that the other activities he had engaged upon in a rather disheartening struggle for existence might reflect adversely upon his family. So it was as Lawrence Griffith that he had become an actor in Louisville, making his debut at a charity performance, then faring forth with a troupe of local entertainers[1] and, finally, after an earlier unsuccessful attempt, joined the Meffert Stock Company. Here at the Masonic Temple Theatre, Griffith appeared twice a day in supporting roles through the season of 1897-98 and again, briefly, at the end of 1898-99 season. Louisville residents still speak affectionately of the old Temple Theatre, long since destroyed by fire. Matrons who attended it as girls recall that they secretly entertained a romantic passion for the com-

pany's leading man, Oscar Eagle. But local recollection of the tall young fellow who appeared now as the footman in *Little Lord Fauntleroy*, as Parker Serrant in *Lady Windermere's Fan*, or as Athos in *The Three Guardsmen* is not particularly vivid.

The nineties were in their full glory then and the theatre—as it no longer is now—an absorbing and vital part of the social and intellectual life of the nation. Intensely musical and theatre-conscious Louisville, for instance, supported at that time not only the Temple Theatre, the Auditorium (for major attractions like Sousa's Band or Sarah Bernhardt), the Avenue Theatre (melodrama and buckets of blood), the Buckingham Theatre (burlesque), the Bijou Theatre (variety), but also the justly famous Macauley's Theatre which, for long years, drew unto itself the greatest of stage celebrities from all over the world. Here Mary Anderson made her debut and here Modjeska produced the first Ibsen play in the United States.

Here, too, the young Griffith, from the gallery, had seen Julia Marlowe in *Romeo and Juliet* and forthwith determined to become an actor and a dramatist. He could glimpse from afar local celebrities coming over after dinner at the Pendennis Club to greet their acquaintances in the boxes and parquet of the large horseshoe-shaped theatre, strolling out between acts to visit the stars backstage or drop in at the Crockford and enjoy "one fried oyster or sausage with each drink, except a schooner." But Griffith, by reason of his youth and poverty, stood on the outer fringes of all this gaiety, as he did too of less decorous amusements which the pleasant city offered—concert halls like Beirod's with its lively orchestra and ambulant hostesses, and the innumerable establishments on Green Street where, in one back room at least, a colored pianist, strayed upriver from

[1] It consisted of Jim White, a stage-struck blacksmith, of Ned Ridgely, steamboat comedian and small-town barnstormer, of Griffith, and occasionally of landlords who took out in histrionic experience what they had been unable to collect in rent.

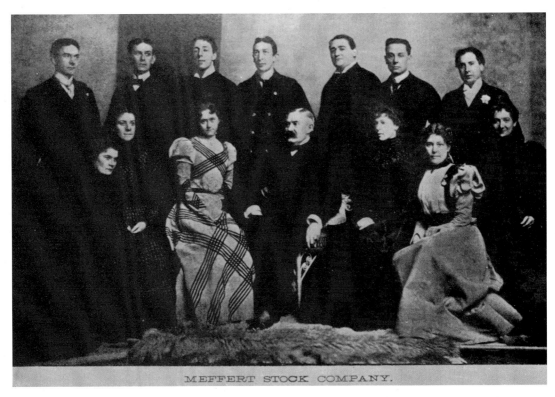

MEFFERT STOCK COMPANY.

"Lawrence" Griffith, third from the left at the back, with the Meffert Stock Company in Louisville, 1897-8.

New Orleans or Memphis, was already strumming out a strange ragtime rhythm of his own. "Jerry played everything with that chop beat," a contemporary recalls. "But we were more concerned with the harpist in the Temple Theatre orchestra. After the show we used to load him and his harp on to a cab and go round serenading our sweethearts." Meanwhile Griffith had been taking singing lessons and attending the Methodist Sunday School. Buying tickets for the theatre, before he became an actor, must have entailed quite a sacrifice.

The boy's background was one familiar enough, of high traditions, past glories and present straits. His paternal great-grandfather, Salathiel Griffith, deputy-constable and sheriff of Somerset County, Maryland, was a considerable citizen[2] of the young republic. His

grandfather, Daniel Weatherby Griffith (presumably Salathiel's youngest son) resided in Charlestown, Jefferson County, Virginia,[3] but in 1840, twice widowed, moved on west to Kentucky where his twenty-year-old son, Jacob Wark Griffith, seems already to have settled. Property had also come to them through Daniel Griffith's first wife, Margaret Wark.[4] Jacob Griffith studied and practised medicine in Floydsburg, fought at Buena Vista and Saltillo in the Mexican War, and went west as captain-escort of one of the innumerable wagon-trains leaving Missouri for California in 1850. During

[2] He left the 100-acre property "Safe Guard" in Worcester County, Maryland, to his daughter Nancy Beauchamp; a negro girl to his grand-daughter Nancy Owen Bowles; the property "Abergildie" in Somerset County, Maryland, to his son Merlin, and the rest of his estate (save for one negro woman who was to obtain her freedom) to his sons Jefferson, Salathiel William and Daniel Weatherby, who were to be apprenticed as soon as they were old enough. (Maryland Orphan's Court, Somerset County, Liber E.B. No. 17 folio 460, 461, 462.)

[3] Now West Virginia.

[4] See Deed Book 21, p. 228 et seq., Clerk's Office of the County Court, Jefferson County, West Virginia.

the sessions of 1853-54 he was a member of the Kentucky legislature. In 1848 he had married Mary Perkins Oglesby, a member of the Carter clan of Virginia. A son who survived but a few months, a daughter, a son and another daughter had been born on the Griffith place near Crestwood, Oldham County, Kentucky, before the outbreak of the Civil War found Captain Jacob in command of Company E., First Kentucky Cavalry, C.S.A. Soon promoted to lieutenant-colonel of the second organization, he was severely wounded at Hewey's Bridge and at Sequatchie Valley. Late in 1863, the Colonel's figure loomed picturesquely through national history when—badly wounded for the third time and unable to walk—he commandeered a horse and buggy and in it led his regiment to a victorious charge. His great booming voice had already earned him the soubriquet of "Roaring Jake" Griffith.[5] Surrendering to the victorious North at Irwinville, Georgia, on May 10th, 1865, after vainly attempting to escort President Davis westward to safety, he returned to the home which his wife—like so many other wives —had been struggling to keep going through the years of conflict.

The Griffith place at Crestwood no longer stands: a newer farmhouse was built on its site in 1911 and recently the last of the tall cedars round the old house and all of the avenue of trees running up to it, a full quarter of a mile from the La Grange-Louisville turnpike, have been cut down. It was probably never a "great" house, certainly the land was never very rich: hazards of war raging back and forth across neutral Kentucky impoverished it further. By the time of David Wark Griffith's birth on January 23, 1875, a few months before the first Kentucky Derby, the constant struggle with poverty had become acute. Colonel Griffith, again elected to the Lower House from his district in 1878, seems, from the kindly reports of surviving relatives, to have been something of a visionary, and improvident. At any rate, after his death in 1885 it appeared that he had been

paying ten per cent compound interest on several mortgages: there was less than nothing left.

CASHBOY, JOURNALIST, TROUPER

D. W. Griffith's earliest and psychologically quite interesting memory is of attending a magic-lantern show in the village school along with his father, for whom he preserves an almost idolatrous admiration. But later memories are of driving cows home through a menacing dusk, of bullies at the local school, of riding into Louisville atop a cart laden with the family's sole remaining possessions when, in his teens, poverty had driven the widow and younger children from their birthplace to an even more pinched farm and, finally, into the city.

The boy Griffith helped out as best he could, now as cash-boy in Lewis' Dry Goods Store, where he was embarrassed to be seen by more prosperous friends of his father's, now as errand boy in the Flexner bookstore. He seems also to have had a job on the *Louisville Courier*, and in a second dry goods store. Once he was a super at the Auditorium, probably when Sarah Bernhardt appeared in *Gismonda* and *The Lady with the Camellias* in 1896. But when he finally joined the Meffert Stock Company he brought with him to the eager performance of modest roles little more than a Southerner's sense of personal and tribal importance, a familiarity with Shakespeare and the Bible read out loud at night by lamplight in the old home by the aging Colonel, his father, together with a resonant voice and diction of remarkable purity.

After leaving the Meffert Stock Company, "Lawrence" Griffith continued to be an actor with little pecuniary success, touring with a number of companies which commonly folded up en route, leaving the cast stranded. By his own account,[6] he was almost penniless, frequently fired and often compelled to resort temporarily to other means of livelihood. The

[5] In his late years "Roaring Jake" enjoyed immense local fame for the Shakespearean readings he gave at church socials. People would drive in from miles around to hear him.

[6] These and many other details are drawn from the incompleted manuscript of an autobiography of *D. W. Griffith and the Wolf* which Mr. Griffith permitted us to consult.

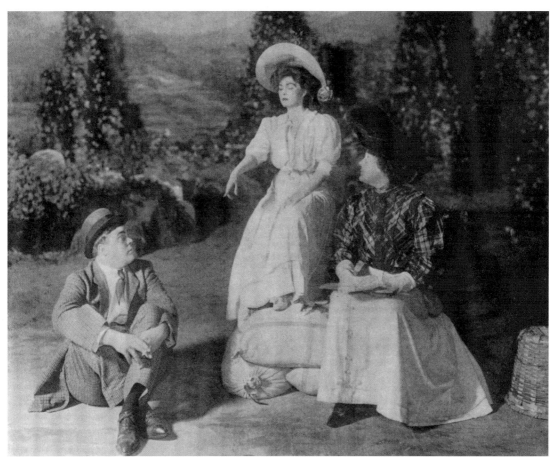

A Fool and A Girl, a play written by Griffith and produced by James K. Hackett in Washington in 1907. Fanny Ward (center), Alison Skipworth and Frank Wundelee. (Photo courtesy of the Theatre Collection, New York Public Library.)

details of these years are not too clear. There was a period when he sold subscriptions to *The Baptist Weekly* and the *Encyclopaedia Britannica* in rural Kentucky. We know that he left Louisville for New York with $19, secured a small part in a melodrama which expired in Tonawanda, New York, where he worked as an ore shoveler until he had the fare back to Broadway. Engaged at $25 a week in a *London Life* road company, he was stranded in Minneapolis and beat his way back to Louisville with difficulty. Again New York, flop-houses, a construction job, then comparative success as a member of Ada Gray's company on her farewell tour in 1904, during which he played small roles in *Trilby* and in *East Lynne.* The same

year we trace him in Chicago as Abraham Lincoln in *The Ensign* with the Neill Alhambra Stock Company, and the next year with the Melbourne MacDowell Company in *Fedora.* He was again stranded or fired in Portland, Oregon, worked his way up and down the coast on lumber schooners, picked hops, played in *The Financier* in San Francisco and in *Ramona* in Los Angeles; then joined Nance O'Neill's *Elizabeth, Queen of England* as Sir Francis Drake. He toured with this company from January to May, 1906, at which time, still with the same company, he appeared in *Rosmersholm* and *Magda* in Boston and there married Linda Arvidson Johnson, a young actress whom he had met the previous year in San Francisco.

Still no great success blessed him, though James Hackett unexpectedly paid him $1,000 for *A Fool and a Girl.* But otherwise 1907 was a lean year, the failure of the play was undoubtedly a keen disappointment, and Griffith was compelled once more to look for employment outside the theatre. This time he tried something new—the motion pictures.

Movies were no longer a novelty, for they had established themselves as a public entertainment in 1895 and by now were fairly prevalent: but they had established themselves in amusement parlors or as the final, and expulsive, turn in variety shows, and they ranked little above a flea circus. Actors, particularly, had a huge contempt for them and for the people who played in them. This seems curious, since Joseph Jefferson had appeared in a series of the early mutoscopes and Sarah Bernhardt enacted the duel scene from *Hamlet* for the screen in 1900. The fact remained that even an obscure actor "at rest" regarded work in the movies as rather worse than death.

Now under financial compulsion Griffith set out on the round of the various film firms to try to sell ideas for film stories. At the Edison studio he saw Edwin S. Porter who, four years before, in THE LIFE OF AN AMERICAN FIREMAN and THE GREAT TRAIN ROBBERY, had laid down the basis for cinematic story-telling on which Griffith later was so eminently to build. Porter refused Griffith's offer of a scenario based on *La Tosca* but offered him the leading part in a film he was about to make—RESCUED FROM AN

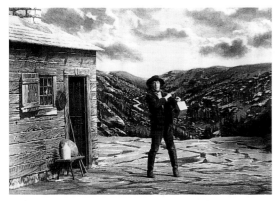

The screen debut of "Lawrence" Griffith in RESCUED FROM AN EAGLE'S NEST, 1907. F.

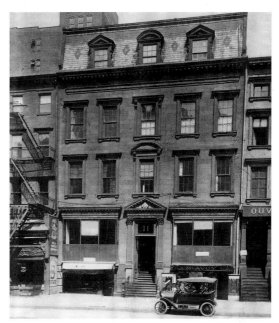

The Biograph Company's premises at 11 East 14 Street, New York. (Photo courtesy of *Photoplay.*)

EAGLE'S NEST. Griffith accepted, reluctantly, and as this film has been preserved we are able to witness his screen debut at very nearly first hand. The style is still approximately that of THE GREAT TRAIN ROBBERY, with painted canvas exteriors alternating with real ones, simple action which called for no explanatory wordage, and all actors seen full-length and moving for the most part horizontally as on the stage. Griffith, a fine figure of a man, gives a robust performance but his woodsman-hero and the other adult participants in this "Western" tale are not much more convincing than the eagle.

BIOGRAPH DAYS

Shortly afterwards he presented himself at the old Biograph Studio on 14th Street, again with plots for sale, and here met with a more permanent success. He sold several stories, among them OLD ISAACS THE PAWNBROKER, which was filmed in March, 1908, OSTLER JOE, and AT THE CROSSROADS OF LIFE. In these last two he, no doubt still reluctantly, also acted as he did, too, in THE MUSIC MASTER and WHEN KNIGHTS WERE BOLD. The price for a story was usually $15 and actors were paid $5 a day. The

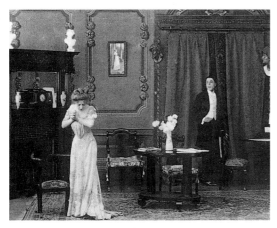

D. W. Griffith as a film actor with Marion Leonard in AT THE CROSSROADS OF LIFE, 1908. F.

at this period its productions seem to have been less successful. Rival firms were stealing the lead and there had been much litigation over patent rights. By 1907 Biograph was selling less than twenty prints of its subjects, and the employees were pretty worried. The advent of Griffith into the firm rapidly proved to be extreme good fortune.

Griffith's companions in the studio noticed that he was a "human short-circuit type": his energy and initiative soon earned him the chance to direct a picture, THE ADVENTURES OF DOLLIE, a little story which bore some resemblance to the English-made success of a few years earlier, RESCUED BY ROVER. The cameraman was to be Arthur Marvin, brother of the firm's general manager, H. N. Marvin, but some instruction left in the art of direction was volunteered to the novice by the firm's other photographer, G. W. "Billy" Bitzer, who had joined the firm in 1896 as an electrician. "The cameraman was the whole works at that time," Bitzer writes, "responsible for about everything except the immediate handling of the actors. It was his say not only as to whether the light was bright enough but make-up, angles, rapidity of gestures, etc., besides having enough camera troubles of his own. . . . I agreed to help him [Griffith] in every way. He needed a canvas covering for a gypsy wagon. I would get that, in fact all the props. Also I offered

first Mrs. D. W. Griffith, who has left an account of this period in *When the Movies were Young*, had also obtained work with Biograph as an actress but kept her relationship to "Lawrence" Griffith a secret. Soon he was a fixture at Biograph. In scanning the synopses of the films of that time as advertised in the Biograph bulletins it is evident that he had much to contribute from the start, though as yet it was only a rather more complex and probable type of plot than had been customary.

Biograph had fallen on difficult days at the moment Griffith joined it. Created in the very infancy of the movies, the American Mutoscope and Biograph Company had at first provided keen competition to the Edison kinetoscope with its own variant of the peepshow known as the mutoscope, a series of cardboard pictures set in a wheel and flipped over by a crank. Next it provided a lively rival to the Edison films with its own variety of large-size motion pictures. These "Biographs" had started out famously in 1896 with a little railroad film, THE EMPIRE STATE EXPRESS, and with shots of presidential candidate McKinley. Its first roof-top studio thereafter produced an extremely remarkable series of short pictures which, after 1903, began to utilize more plot and less mere incident, after the model of THE GREAT TRAIN ROBBERY. In 1906, with the advent of suitable artificial illumination, the firm moved indoors to 11 East 14th Street, but

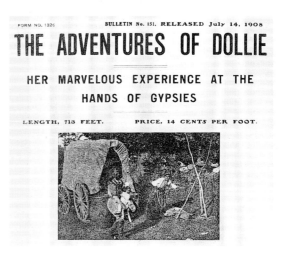

Trade advertisement for the first film directed by Griffith.

to condense the script and lay out the opportunities it had so that he would be able to understand it. . . . He came to my house a few evenings later. He had been looking for a suitable location, wanted a swift, running stream quite close to a house. I had divided off half a dozen columns on the back of a laundry shirt-cardboard and headed the columns with titles—Drama, Comedy, Pathos, Pretty Scenes —and wrote in what I thought he should stress. . . . Judging the little I had caught from seeing his acting I didn't think he was going to be so hot. He was very grateful for this and some other tips I gave him. All through the following sixteen years that I was at his side he always was not above taking advice, yes, even asking for suggestions or ideas. He always said to me, 'Four eyes are better than two.' "

EARLY SUCCESSES

Thus began one of the most remarkable associations in the history of the motion picture and thus inconspicuously did "the Master" enter upon his career. THE ADVENTURES OF DOLLIE was an immediate success and from then on Griffith, with Marvin or Bitzer behind the camera, worked at film making for fourteen hours a day. Sales bounded up. The studio on 14th Street had space for only one set at a time, but though it is true that the finished films never exceeded one reel by more than a few feet and the total footage shot was never more than 1,600—usually it was well under 1,000—it is astonishing how very many films were turned out. Apparently *all* Biograph films from June, 1908, until December, 1909, were made by Mr. Griffith, and all the important ones thereafter until 1913, at the rate of one twelve-minute and one six-minute subject every week. It is an amazing bulk, of amazing variety but even more amazing in its liveliness and in the vitality with which this newcomer's work developed.

While the Museum of Modern Art Film Library was fortunate in obtaining recently all that remained of the Biograph product and papers, much of the film had already perished beyond recovery: there were few prints, and

those mostly in poor condition, while all too many of the negatives were in a state of disintegration, chemical action or moisture having quite ruined them. Moreover, the Biograph films of the period under review were made on stock with only two sprocket holes, so that it is impossible to make prints from such negatives on modern printing machines. It was only through the painstaking efforts of a member of the Film Library's staff, Mr. William Jamison (long associated with the Edison Company) that a means was found of obtaining prints from such of the negatives as were still in fair or good condition: he salvaged and practically remanufactured an old printing machine for the task. Mr. G. W. Bitzer (who has also been temporarily attached to the Film Library's staff for some months past) likewise lent his extraordinary resourcefulness and experience to the adaptation of an original Biograph camera so that it might be used as a projector. This is most helpful for the examination of negatives and obviated the expense of making up prints of the many subjects to be examined. It is thanks to these two tireless pioneers that it has finally been possible for us to restore at least some of the early work of Mr. Griffith to the screen. Even so, the first two films he directed are lost and the earliest one recovered, THE BLACK VIPER, is not especially interesting.

Griffith's prentice work was of such quality, however, and pleased the public so well that on August 17, 1908, the firm signed him up at $50 a week, plus a guaranteed weekly commission of not less than $50. Between this date and his second contract[7] with Biograph in 1909 he made a hundred and thirty-one films, another hundred before his third contract[8] in 1910 and a further ninety-five before the fourth contract[9]

[7] August 2, 1909, Griffith signed a second contract at $50 a week plus $1/10$ of 1 per cent for each lineal foot of positive film sold. The firm to pay him the difference should this commission plus salary in any week be less than $100.

[8] August 1, 1910, Griffith signed a third contract at $75 a week plus a commission of $1/8$ of 1 per cent for each lineal foot of positive film leased or sold, the firm to make up the difference should this commission plus salary in any week be less than $200.

[9] November 11, 1911, Griffith signed a fourth contract at $75 a week plus a commission of 1 3/4 mills for each

A CORNER IN WHEAT, 1909. F.

Many of Griffith's early films presented social problems, as here in A CORNER IN WHEAT.
F.

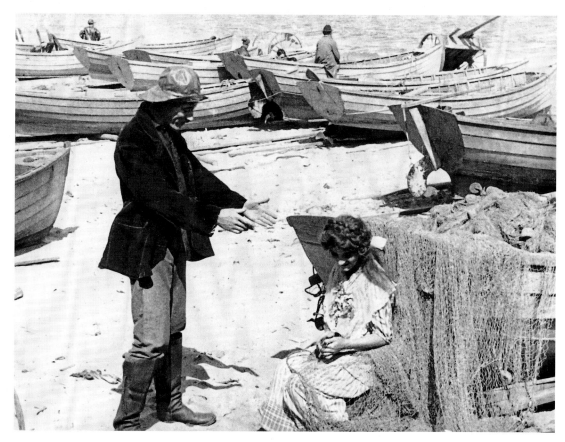

Stage conventions abandoned, new realism apparent in LINES OF WHITE ON A SULLEN SEA, 1911. F.

in 1911. Whereas the first two contracts were made out to Lawrence Griffith it is interesting to note that Lawrence is altered to David in pen in the third contract and that the fourth contract is made out directly to David Wark Griffith. Knowing how Griffith felt about the use of his real name, we can deduce that the degree of success and self-expression which attended his efforts had by now reconciled him to working in motion pictures. And well it might, for single-handed he was forging a new medium of expression out of them.

Edwin S. Porter in THE GREAT TRAIN ROB-BERY had taken a vital step by introducing parallel action through a rough form of cross-cutting, thus introducing a radically cinematic method of telling a story quite unlike the stage-

bound method employed earlier. Porter had discovered the film's ability to juggle with time and space or to follow a continuity unlike that of normal experience.

TECHNICAL INNOVATIONS

Griffith, starting with Porter's method as still employed in RESCUED FROM AN EAGLE'S NEST, set out to improve this new-found instrument. He was fortunate in obtaining the collaboration of Bitzer, a craftsman-photographer who could be persuaded to experiment, often with miraculous success.[10] For example, already in August, 1908, in FOR LOVE OF GOLD Griffith demanded a change of camera set-up in the middle of a scene. This was an unheard of practice. It is remarkable that a man stage-trained as he was should have felt immediately

lineal foot of positive film leased or sold, the firm to make up the difference should this commission plus salary in any week be less than $200.

[10] See pp. 34-37.

a necessity thus to liberate the motion picture from stage forms and conventions and to compose his film out of brief shots taken at varying distances from the action. But his theatre experience at the same time furnished him with a wealth of plots, as for instance in September, 1908, when he drew upon the then familiar play *Ingomar the Barbarian* for one of his pictures. In view of what was to come it must be noted that in November of that year he made his first Civil War subject, THE GUERILLA, and in the same month for the first time used a social problem as the basis of one of his film plots—THE SONG OF THE SHIRT.

The Griffith-Bitzer collaboration was working well. Early in 1909 they together contrived a strikingly novel effect of light and shade in EDGAR ALLAN POE, and a firelight effect which was widely remarked in the otherwise primitive and stilted A DRUNKARD'S REFORMATION. By June, 1909, Griffith was already gaining control of his material and moved to further creative activity: he carried Porter's initial method to a new stage of development in THE LONELY VILLA, in which he employed cross-cutting to heighten suspense throughout the parallel scenes where the burglars are breaking in upon the mother and children while the father is rushing home to the rescue. Here he had hit upon a new way of handling a tried device—the last-minute rescue—which was to serve him well for the rest of his career. By March,[11] 1911, Griffith

Enlargements from frames of THE LONELY VILLA, 1909, in which Griffith made use of cross-cutting for suspense: Marion Leonard, Mary Pickford, Adele de Garde and C. H. Mailes. F.

Innovations in lighting: Linda Arvidson and Herbert Yost in EDGAR ALLAN POE, 1909. F.

[11] From January, 1910 on, the company wintered in California. Mrs. Griffith's book gives many picturesque details of trips on location to Cuddebackville and of adventures in the real Wild West which well illustrate the tenor and spirit of those fourteen-hour days. According to Bitzer, from the time he entered Biograph until he attended the Boston opening of THE BIRTH OF A NATION in April, 1915, Griffith himself took not even one day's vacation. He and his company were a hard-working and highly cooperative bunch, not well paid by present-day standards but

further developed this disjunctive method of narration in THE LONEDALE OPERATOR, which achieves a much greater degree of breathless excitement and suspense in the scenes where the railwayman-hero is racing his train back to the rescue of the heroine attacked by hold-up men in the depot. A comparison of the two films—THE LONELY VILLA and THE LONEDALE OPERATOR—shows how far Griffith had progressed in the interim. The camera is used with far more flexibility in the later film and there is a wider variety of set-ups and angles. Perhaps even more noticeable is the brevity and terseness with which each shot is edited. In THE LONELY VILLA many scenes begin quietly with the entrance of the characters into the set, significant action follows this slow-paced start only belatedly. In THE LONEDALE OPERATOR there is no leisurely entrance, the characters are already in mid-action when each shot begins and there is no waste footage—no deliberation in getting on with the story when haste and excitement are what is needed. Griffith was relying confidently upon his images to speak eloquently and immediately to the eye and the emotions.

buoyed up by the success of their work and the feeling, surely, of being in the thick of something both vigorous and novel. The actors contributed stories and helped with one another's costumes and make-up, the cameraman was not above handling props, the director cut his own film, anybody around the studio would enact a part or do a laborer's job if necessary.

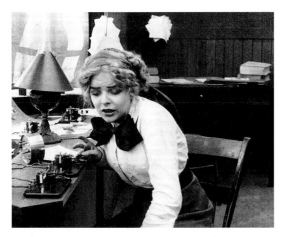

Blanche Sweet in THE LONEDALE OPERATOR, 1911

Linda Arvidson and Mary Pickford in THE UNCHANGING SEA, 1910. F.

But he was introducing many other innovations and improvements. Gradually (over considerable protest) he was bringing the camera closer and closer to the actors in scenes where it was important to indicate emotional interplay or where small gestures or expressions were of special interest. This had two results: it identified the audience more closely with the action while it also made the acting much quieter and more intimate. Now very long shots were also introduced, first in RAMONA (May, 1910), and afterwards whenever desirable to open up the dramatic horizon, whether for atmosphere or for action. The confines of the stage, so oppressive in earlier films, were being broken, movement in any direction on the screen was employed freely and the motion picture began finally to be a fluid, eloquent and utterly novel form of expression.

Fortunately this creative achievement in a new art form was undertaken so recently that there exists any amount of first-hand evidence as to its effect upon audiences of that time. Mr. Joseph Wood Krutch, for example, vividly recalls that as a boy in Knoxville he and his companions awaited the Biograph pictures of the period with zest because they found them much livelier, more convincing and exciting than other films of the time. Biograph became a name to conjure with, moviegoers were keenly aware of the superiority of its films and began to grow attached to the players in them. But

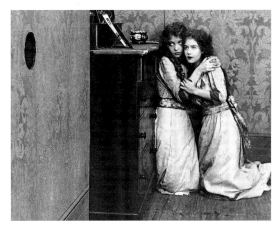

Lillian and Dorothy Gish at the time of their screen debut in AN UNSEEN ENEMY, 1912. F.

the man who made the films and the people who acted in them were still anonymous.

Griffith had been instrumental in inducing several competent stage actors to follow his lead and engage in the despised movies—Arthur Johnson, long a leading man in Biograph films, was prominent among them and so was Frank Powell, later to become famous as the inventor of the screen "vamp" and discoverer of Theda Bara when he directed A FOOL THERE WAS (1914). But as Griffith induced Bitzer to take closer and closer shots of the actors, the brilliant Biograph camera became harder and harder on the human face, whether in daylight or in the artificial lighting which was gradually being introduced. Griffith there-

fore began to gather round him very young people on whose round cheeks time had not yet marked a single line. One of them was a sixteen-year-old veteran of the stage, Mary Pickford, who first played bit parts in WHAT DRINK DID and THE LONELY VILLA and a larger role in THE VIOLIN MAKER OF CREMONA. Three other important newcomers were Blanche Sweet, heroine of many a Biograph picture, Mabel Normand, and Mae Marsh. August, 1912, brought the two little Gish sisters in AN UNSEEN ENEMY. Robert Harron, at first a studio errand boy, soon graduated to acting: Mary Pickford brought along her young brother Jack. Griffith's method of operation was one well suited to such sensitive children—he customarily rehearsed his scenes until everyone was easy in his role and the cameraman satisfied that all would go well. At no time did he use a scenario. But there was considerable protest

Anita Loos at the time she was writing scenarios for the Triangle Corporation.

when, quite early in his directorial career, he insisted on retaking unsatisfactory scenes and succeeded in gaining permission to do so in THE LONELY VILLA. Bitzer and others were aghast at his extravagance with film.

Yet another innovation was increased length. In May, 1911, against considerable opposition Griffith insisted upon making ENOCH ARDEN in two reels instead of in the customary one: it is true that each reel was released separately, for there was an obstinate belief that audiences could take no more than twelve-minute-long stories at a time. This belief was to be dispelled, however, by the importation of foreign films of far greater length—innovations in the motion

Lillian Gish at the left in THE MUSKETEERS OF PIG ALLEY, 1912. F.

picture as elsewhere have often been accepted more readily when introduced from Europe than when put forward at home. But Griffith has the credit for realizing that the time had come for a larger canvas.

In 1912 Griffith was ready to progress further. He found himself with plenty to say and a new ease in saying it. Social problems had not ceased to interest him and, late this year, he made one of his finest short pictures, THE MUSKETEERS OF PIG ALLEY. Whether as a study in realism, as an ancestor of the gangster films of later decades, or as an exercise in motion-picture composition this is a remarkable piece. The photography is extraordinary and the whole film predicts what was to come in the modern section of INTOLERANCE. Another noteworthy picture of that year was THE NEW YORK HAT, with Lionel Barrymore as Mary Pickford's

champion. This film uses cut-backs, close shots and sharply edited scenes with ease and mastery: close-ups made acting a matter of expression and minute gesture instead of the stereotyped gestures of the popular theatre. The plot for this charming little picture had been submitted by Anita Loos, a sixteen-year-old stage actress in San Diego. At this period, ideas for films were commonly bought from outsiders and members of the company alike. Mary Pickford, Mack Sennett and others contributed many of the plots Griffith used.

It is remarkable to what an extent Griffith's films of contemporary life appear, in retrospect, to excel his period or costume pieces. This is chiefly due to the unconvincingness of the coiffures, costumes, gait, gesture and general air of the actors in period films, whereas the contemporary material has, by now, the un-

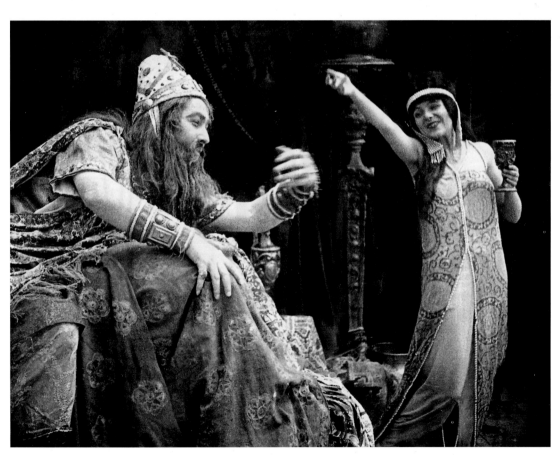

Henry B. Walthall and Blanche Sweet in JUDITH OF BETHULIA, 1913. F.

mistakable veracity of photography by an Atget or a Brady. For this reason it is actually rather difficult to see today why MAN'S GENESIS of June, 1912, was an important stepping-stone in the whole Griffith progress—yet it unquestionably was one. Described as "a psychological study founded upon the Darwinian Theory of the Evolution of Man," its story of the conflict between brute force and intelligence in a rather sketchy Stone Age provoked discussion and brought a new measure of respect for the motion picture. Griffith felt encouraged to make films with a message. Before long he was to attempt an even more ambitious costume subject of considerable importance—JUDITH OF BETHULIA (1913), the first American four-reel subject. It remains both in his own career and in the memories of those who saw it at the time a real landmark. Lewis Jacobs in *The Rise of the American Film* writes of it: "The unusual form of JUDITH OF BETHULIA, modeled on the four-part pattern of Griffith's earlier PIPPA PASSES, presaged the form of Griffith's future masterpiece, INTOLERANCE. The four movements were in counterpoint not unlike a musical composition; they reacted to each other simultaneously, and the combination produced a cumulative, powerful effect. The individual episodes had a tight internal structure. The imagery was not only lavish in detail but fresh in camera treatment and enhanced by expert cutting." I understand that Mr. Griffith does not like it said that the example of the longer Italian films of the period like QUO VADIS had put him on his mettle and encouraged him to fight for the right to make longer films himself, but I believe it to be true. He did not see QUO VADIS but its very existence made his task easier. JUDITH OF BETHULIA, by reason of its length, its intricate composition, its emotional power, its ambitiousness and costliness, provided a fitting climax to his long connection with Biograph, though it is also a film which it is difficult wholly to admire today. The company was not prepared to grant him the freedom for expansion which he sought and, late in this year, he severed his connection with it, taking along with him Billy Bitzer and most of the actors and actresses he had gathered

about him through the past three years. By now they had emerged from anonymity and were rapidly earning world fame.

Bitzer's recollections of the period are illuminating. "When Mr. Griffith decided to leave Biograph," he writes, "I refused to join with him, although he offered to treble my salary. I didn't think the independent outfit he was going with could possibly stand the gaff of Mr. Griffith's spending of both film and money. Among the inducements Mr. Griffith pictured to me was one in which he said, 'We will bury ourselves in hard work out at the coast . . . for five years, and make the greatest pictures ever made, make a million dollars, and retire, and then you can have all the time you want to fool around with your camera gadgets, etc., and I shall settle down to write.' Now I thought how can he be so sure of that when even now in the pictures we had . . . we never did know whether we had a best-seller until it went out?"

THE BIRTH OF A NATION MAKES FILM HISTORY

But Griffith was persuasive and so was Mr. Harry Aitken, with whom he had now joined forces under the banner of Mutual films, and Bitzer went along. All was not smooth sailing at first. Griffith rushed THE BATTLE OF THE SEXES through in four days' shooting to provide funds to meet the payroll. "One could sense the money worry from the beginning. . . . They had to hock THE GREAT LEAP, which Christy Cabanne directed, to pay the railroad fares of Mr. Griffith's company to the coast. There wasn't a thing I could see on the horizon of a picture of pictures that would make a million dollars. . . . However, we went along with THE ESCAPE, THE AVENGING CONSCIENCE and HOME SWEET HOME." All three of these films were made at an anxious time, possibly Griffith gave over the task of making them to other helpers for they do not (except in flashes and in their ambitious length) really exceed or perhaps even equal the quality of the best Biograph work that preceded them.

Griffith's mind was on the really big picture he was now planning, a story of the Civil War

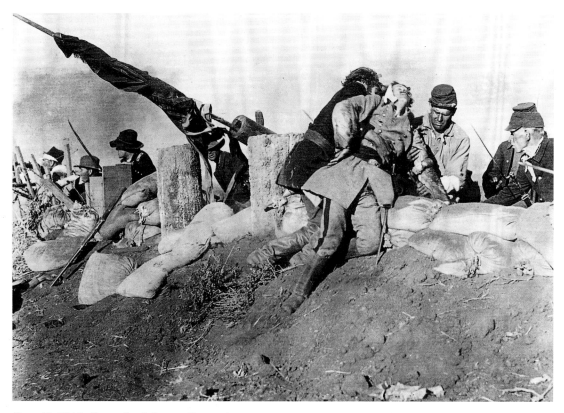

Henry B. Walthall, as a Confederate officer in THE BIRTH OF A NATION, is rescued by a boyhood friend, now a Union officer. F.

and of Reconstruction based on Thomas Dixon's novel *The Clansman*. This of course was that "greatest picture ever made" of which Griffith had spoken to Bitzer, which we now know as THE BIRTH OF A NATION.

Bitzer continues: "THE BIRTH OF A NATION changed D. W. Griffith's personality entirely. Where heretofore he was wont to refer in starting on a new picture to 'grinding out another sausage' and go at it lightly, his attitude in beginning on this one was all eagerness. He acted like here we have something worthwhile. . . . Personally I did not share the enthusiasm. I had read the book and figured out that a negro chasing a white girl was just another sausage after all and how would you show it in the South?" However, cameraman and director were perfectly *en rapport*; Bitzer could tell by the look of the back of Griffith's head or a wiggling of his foot whether any given scene had gone well or not. The company was

particularly well rehearsed, everyone flung himself into this new, unbelievably long and ambitious picture. Before it was over the money began to run out: members of the cast and Bitzer chipped in. Griffith called for new and unheard of effects, he even wanted close-ups of the flying feet of the mounts of the riding clansmen. Bitzer, down on the ground, did his best as the Klan advanced upon him in a cloud of dust, horses as well as riders half-blinded by flapping sheets. One side of the camera was kicked in, but Bitzer came through. The film was finished; it was cut; a special musical score had been composed for it; it was 12 reels long. Who had ever heard of anything of the sort, who would show it? Griffith was already his own money-raiser, producer, casting director, and now had to become his own publicist as well. The few audiences on whom THE CLANSMAN had been tried out were swept away by it. A statesman declared it was "like writing

21

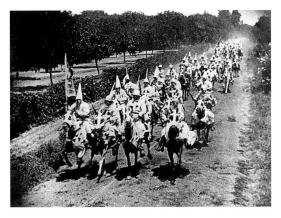

The Ride of the Clansmen, from THE BIRTH OF A NATION, 1915. F.

history in lightning." The film opened in New York at the Liberty Theatre at $2 a ticket. The most important single film ever made was thus given to the public. The response was overwhelming: people had not realized that they *could* be so moved by what, after all, is only a succession of photographs passed across a screen. All depends, they found, upon what is the order and manner of that passing. THE BIRTH OF A NATION, which had cost about $100,000 to make, grossed $18,000,000 in the next few years. Even more important, it established the motion picture once and for all as the most popular and persuasive of entertainments and compelled the acceptance of the film as art.

Josephine Crowell, Henry B. Walthall and Lillian Gish in THE BIRTH OF A NATION, 1915. F.

The film, however, aroused much opposition and censure (see Ramsaye: *A Million and One Nights*. New York, 1926, pp. 641-644). Its subject matter is of a controversial and—to many people—inflammatory nature, though Griffith himself certainly believed he had honestly and impartially told the truth about the South after the Civil War. But he also realized how rich a means of expression he had at his command in this new medium which he himself had so conspicuously helped to develop, and he very naturally insisted on the right of the motion picture to share with literature the privilege of free speech. The protests against THE BIRTH OF A NATION, the moves to censor

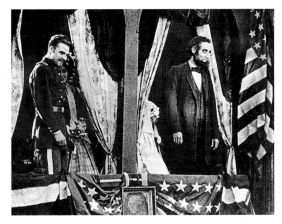

Joseph Henabery as Abraham Lincoln in THE BIRTH OF A NATION, 1915. F.

and muzzle the film threw him into a fighting mood. By his mastery he had unwittingly proved the film to be a most powerful instrument of expression and as a showman he now determined to use it as such.

INTOLERANCE

Before THE BIRTH OF A NATION was released Griffith had almost completed a new picture, THE MOTHER AND THE LAW, a modern story which bleakly revealed the wrongs inflicted by a pious factory owner on his employees and the injustices of which the law may sometimes be capable. Suddenly the new picture seemed to him an insufficiently violent attack on prejudice and cruelty, so that he decided to weave in with

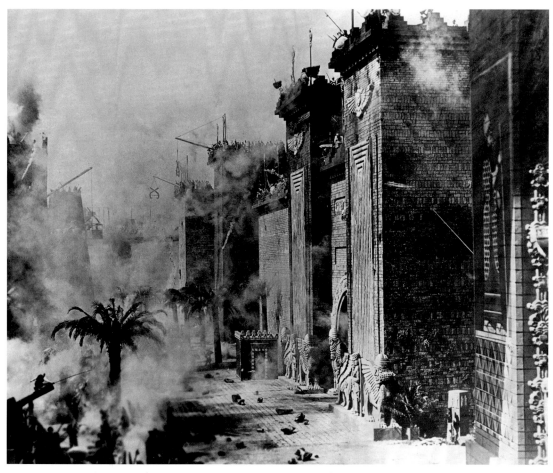

Battle scene from the Babylonian sequence of INTOLERANCE, 1916. F

his modern story three parallel stories of injustice and prejudice in other ages and so make of the film an epic sermon. The slums of today, sixteenth-century France, ancient Babylon and Calvary itself should speak of the evil which the self-righteous have perpetrated through the centuries. He flung up sets of a size hitherto unimagined, hired players by the hundreds, shot miles of film. Into this gigantic undertaking poured his profits from THE BIRTH OF A NATION. His employees were aghast when he ordered them to construct walls so broad that an army could march round the tops of them, palace halls so vast that the crowds in them were reduced to ant-like proportions. Hollywood rang with rumors: the film was two years in the making, yet out of all this footage, extravagance and passion emerged a film of

unmistakable greatness and originality, called INTOLERANCE.

The film INTOLERANCE is of extreme importance in the history of the cinema. It is the end

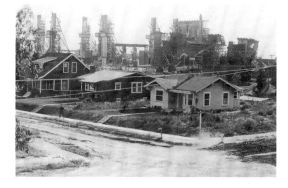

The extravagant Babylonian set, designed for INTOLERANCE, in construction on Sunset Boulevard, Hollywood.

23

Mae Marsh, heroine of the modern story in INTOLER-
ANCE, 1916. F.

and justification of that whole school of Ameri-
can cinematography based on the terse cutting
and disjunctive assembly if lengths of film,
which began with THE GREAT TRAIN ROBBERY
and culminated in THE BIRTH OF A NATION and
in this. All the old and many new technical
devices are employed in it—brief, enormous
close-ups not only of faces but of hands and of
objects; the "eye-opener" focus to introduce

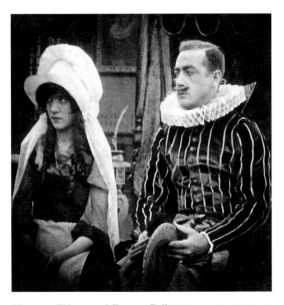

Margery Wilson and Eugene Pallette in INTOLERANCE. F.

vast panoramas; the use of only part of the
screen's area for certain shots; camera angles
and tracking shots such as are commonly sup-
posed to have been introduced by German
producers years later; and rapid cross-cutting
the like of which was not seen again until
POTEMKIN.

The sociological implications of the modern
episode seem, perhaps, more pointed now than
they did in 1916. They undoubtedly account
for the fact that Lenin arranged to have IN-
TOLERANCE toured throughout the U.S.S.R.,
where it ran almost continuously for ten years.
The film was not merely seen there; it was also
used as study material for the post-revolu-
tionary school of cinematography, and exer-
cised a profound influence on the work of men
like Eisenstein and Pudovkin.[12] It is true that
Griffith is largely instinctive in his methods,
where the Russian directors are deliberate and
organized: but it was nevertheless in large
measure from his example that they derived
their characteristic staccato shots, their meas-
ured and accelerated rhythms and their skill in
joining pictorial images together with a view
to the emotional overtones of each, so that two
images in conjunction convey more than the
sum of their visible content.

[12] In September, 1936, Leonid Trauberg, co-director
with G. Kozintsev of such noted Russian pictures as
NEW BABYLON and THE YOUTH OF MAXIM, wrote to
Mr. Griffith from Moscow asking for details of his
biography to be incorporated in a encyclopedic
Lives of Illustrious Men, Trauberg said:
 "I take the liberty to count myself one of your
 pupils, though I think there are hardly such people
 in our art which do not count themselfs so.
 . . . You certainly know what an important effect
 your pictures have had on Soviet cinema directors
 and actors. We have seen your pictures in 1923-4
 —except INTOLERANCE [which we saw.Ed.]in1919—
 i.e. in that time when we all—Eisenstein, Pudov-
 kin, Ermler, Vassilieffs and we two—had just
 begun our work as directors. Under the influence
 of your pictures as BROKEN BLOSSOMS, DREAM
 STREET, WAY DOWN EAST, ORPHANS OF THE STORM
 and others our style has been created. Especially
 lately, during the last 3-4 years we have examined
 your work with more intense interest, chiefly
 because we find in it that power humanity and
 realism which we also try—in our own way—to
 attain in our pictures."

24

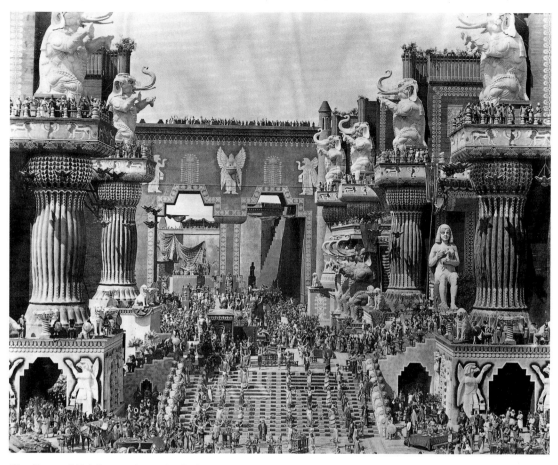

The Feast of Belshazzar from the Babylonian sequence of INTOLERANCE, 1916.

The scale and sumptuousness of JUDITH OF BETHULIA and of INTOLERANCE profoundly affected film-making everywhere. At home, they undoubtedly influenced Cecil B. DeMille, whose name later became synonymous with glittering spectacles. In France, the effect of Griffith's work at this period can be traced in the later productions of Abel Gance, and in Germany, in those of Fritz Lang. He had conferred both magnitude and complexity as well as expressiveness on the motion pictures and in Europe and America alike, all the most ambitious films of the 1920s reflected his influence and followed his example.

Though INTOLERANCE has been revived time and again, especially in Europe, unlike THE BIRTH OF A NATION it was not a great popular success. Audiences find it bewildering, exhausting. There is so much in it; there is too much

of it; the pace increases so relentlessly; its intense hail of images—many of them only five frames long—cruelly hammers the sensibility; its climax is near hysteria. No question but that the film is chaotic, difficult to take in, or that it has many evident faults. The desire to instruct and to reform obtrudes awkwardly at times. The lyricism of the subtitles accords oddly with the footnotes appended to them. The Biblical sequence is weak, though useful dramatically to point up the modern sequence. The French episode seems to get lost, then reappears surprisingly.

Of the Babylonian and the modern episodes little adverse criticism is permissible and only admiration remains in face of the last two reels, when the climax of all four stories approaches and history itself seems to pour like a cataract across the screen. In his direction of the im-

mense crowd scenes, Griffith achieves the impossible for—despite their profusion and breath-taking scale—the eye is not distracted, it is irresistibly drawn to the one significant detail. The handling of the actors in intimate scenes has hardly been equaled either for depth or for humanity, particularly in the modern sequence and most notably—where a last-minute rescue again serves him well—with Miriam Cooper and Mae Marsh racing to the prison as Robert Harron approaches the gallows. This searching realism, this pulsing life comes not only from Griffith's power to mould his players but, in equal measure, from his editorial skill.

The American film industry by now was passing out of the era of small enterprises and quick individual profits into that of high finance and corporate endeavor.[13] Griffith was not a business man and he was wholly an individu-

alist. For the future he would often be operating under difficulties. But for the moment the United States was preparing to enter the European war: J. Stuart Blackton's pro-war and anti-German THE BATTLE CRY OF PEACE and Thomas Ince's anti-war and anti-German CIVILIZATION had already indicated the uses to which films might be put and now it was the moment for propaganda for the Allied cause.

[13] In May, 1915, Griffith together with Thomas H. Ince and Mack Sennett became the star-directors of a new producing organization, Triangle Film Corporation, which introduced Douglas Fairbanks, Sir Herbert Beerbohm Tree and Constance Collier, Raymond Hitchcock, William S. Hart and numerous other stage luminaries to the screen.
The subsequent stages of Mr. Griffith's business career are so involved as to require a separate essay. During his 23-year career Griffith is said to have spent about $20,000,000 on some 400 pictures which earned about $60,000,000.

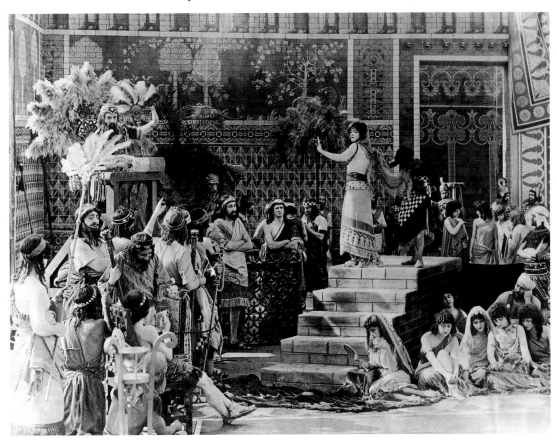

The Slave Market, from the Babylonian Story in INTOLERANCE, 1916.

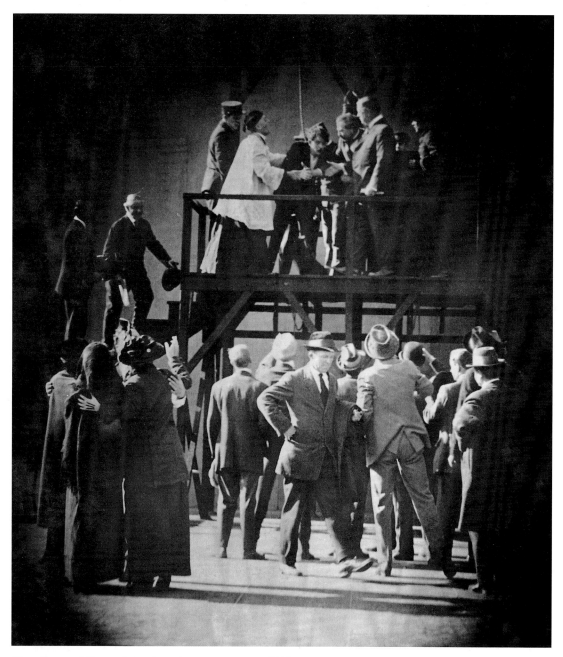

The climax of the modern story in INTOLERANCE, 1916. F.

GRIFFITH IN EUROPE

In the spring of 1917 Griffith received an invitation from the British Government to go to Europe and make a film. This he agreed to do and after a tour of the battlefields began work on HEARTS OF THE WORLD. Part of it was shot in France, part in and around an English village.

HEARTS OF THE WORLD must be judged as a propaganda film and as such it was very effec-

Lillian Gish and Noel Coward in HEARTS OF THE WORLD which Griffith made in Europe for the British Government in 1918.

tive; but otherwise it seems, on the whole, disappointing. One looks in vain for the passionate momentum of its immediate predecessors. In depicting the plight of women and children in a French village behind the lines, it heavily underlines both sentiment and melodrama; the German troops seem almost absurdly "frightful" and the war itself, perhaps of necessity, appears rather sketchy. The film was, however, a personal triumph for Lillian Gish as the distraught heroine, for her sister Dorothy in a comedy role and for Erich von Stroheim as a German officer. No one who saw the film has ever quite forgotten the scenes in which the heroine wanders dazed through the landscape bearing her wedding dress carefully in her arms, or the last-minute rescue as she cowers behind an attic door while "the Huns" batter at it with rifle butt and bayonet.

BROKEN BLOSSOMS

Griffith had been absent from Hollywood almost two years when he returned after launching HEARTS OF THE WORLD. His next important film was to be very different. From the large canvas he turned to an intimate photoplay based on "The Chink and the Child," a short story in Thomas Burke's *Limehouse Nights*. Like most of Griffith's films and all of his best ones it carried a message: the earlier picture

had been his contribution to war, but this fairy-tale of non-resistance in opposition to violence spoke of international tolerance. The part of the London waif might have been made to measure for Lillian Gish and the choice of Richard Barthelmess as the Chinese boy was fortunate. Work went unusually smoothly and, after the customary period of rehearsal, the film was completed in eighteen days.

When BROKEN BLOSSOMS appeared "everyone was overwhelmed," and not only by the discretion and force with which a difficult subject had been handled. Reviewers found it "surprising in its simplicity" and hastened to explain that the photography was misty on purpose, not by accident. The acting seemed a nine days' wonder—no one talked of anything but Lillian's smile, Lillian turning like a tortured animal in a trap, of Barthelmess' convincing restraint. Few pictures have enjoyed greater or more lasting *succès d'estime*.

By 1919 the motion picture was learning fast how to deal freely with ideas and feelings as well as with deeds and here BROKEN BLOSSOMS, despite its rather theatrical form, played an important part by its scaling down of dramatic action and its intensification of intimate emotion. Possibly Griffith had been influenced by the somber Danish films of the period with their emphasis on atmosphere and on moral and psychological reactions,[14] just as formerly it had been he and Ince who taught the Scandinavians to use an isolated face or gesture as a unit of expression rather than (as on the stage) the actor. In the development of the American film, BROKEN BLOSSOMS marked a distinct stage. Definitely a studio picture, it emphasized a new style of lighting and photography which, though it has been abused, was valuable. In its contrasting periods of calm and of violence it borrowed something from INTOLERANCE, just as the grim finale recalls the death of Mae Marsh in THE BIRTH OF A NATION; but there is a sureness and perhaps a sophistication here which had not formerly been evident. Out of BROKEN BLOSSOMS much was to come. It cannot

[14] Mr. Griffith corrects this suggestion: he says that he had never seen any Danish films, although they were rather widely shown.

have been without its influence in Germany; we know that it profoundly affected Louis Delluc and his disciples in France and, but for it, we might never have had Charles Chaplin's A WOMAN OF PARIS.

A D. W. Griffith Repertory Season opened in May, 1919, at the George M. Cohan Theatre in New York with BROKEN BLOSSOMS, followed later by THE FALL OF BABYLON, from INTOLERANCE, "a new peace edition" of HEARTS OF THE WORLD and THE MOTHER AND THE LAW, also from INTOLERANCE. During that summer Griffith moved his company from Hollywood to Mamaroneck, N. Y., where the old Flagler estate at Orienta Point was converted into a studio. Costs had risen sharply and if Griffith was particularly responsible for this he was the first to suffer from it. The complex financial operations that had become part of film production were absorbing more and more of his time. He apparently felt the need to be constantly in or near New York, which was then as now the financial center and shop window of the industry.

Griffith, with Mary Pickford, Douglas Fairbanks and Charles Chaplin, had founded a new joint distribution company, United Artists. THE LOVE FLOWER was the second of his pictures for them, BROKEN BLOSSOMS becoming the first; but in the meantime SCARLET DAYS (1919), THE GREATEST QUESTION and THE IDOL DANCER (all of relatively minor importance) had also appeared through other distributors.

Griffith was now faced with an urgent necessity to turn out a really profitable production. He therefore purchased for $175,000—far more than the entire cost of THE BIRTH OF A NATION— the screen rights to a tried and trusted melodrama, WAY DOWN EAST. For this he was much criticized at first. People considered the play extremely old-fashioned and said that to adapt it for the screen at that date was "as though someone were to try and develop The Old Oaken Bucket into grand opera." Nothing daunted, Griffith set to work in January, 1920, and the company began rehearsal while awaiting snow. All the exteriors were to be real, not studio-contrived. In March, when a blizzard conveniently came along, the snowstorm scenes

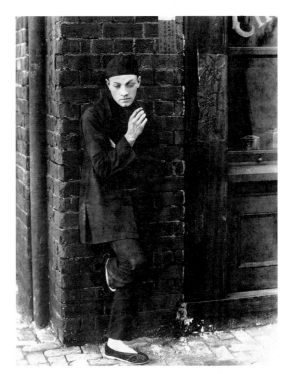

Richard Barthelmess in BROKEN BLOSSOMS, 1919.

were filmed at Mamaroneck, assistants hanging on the legs of the cameras to prevent their being whirled away by the wind, and Miss Gish having to be thawed out at intervals. The ice scenes were then shot at White River Junction, Vermont, under peculiarly uncomfortable circumstances. Albert Bigelow Paine's *Life and Lillian Gish* (New York, Macmillan, 1932) quotes Richard Barthelmess: "Not once, but twenty times a day, for two weeks, Lillian floated down on a cake of ice, and I made my way to her, stepping from one cake to another, to rescue her." The scenes at the brink of the falls were, however, taken much later in the year at Farmington, Conn., with wooden ice-cakes. The actual waterfall shown for a brief moment is Niagara. Since scenes of action of this sort are usually produced today by quite different methods, the facts seem remarkable, but might hardly be worth recording save for the effectiveness with which all these scenes taken at remote times and places were finally assembled.

WAY DOWN EAST

WAY DOWN EAST proved to be one of the most profitable pictures ever made. The master had once more turned the trick. The public was drawn to see an old favorite in a new guise and found its familiar melodramatic qualities heightened beyond expectation. While sticking faithfully to the bones of the play, Griffith had very rightly adapted it to suit the newer medium, notably at the beginning by adding material to establish the background of the characters and at the end to give full rein to the last-minute rescue, developed in purely visual terms and heightened through artful photography and cutting. It was a device which had seldom failed Griffith in the past and stood him in good stead now.

The lapse of time has made it difficult to estimate the qualities of WAY DOWN EAST accurately. Much in it that was fresh and inventive at the time the film was made has since been absorbed into the general repertory of film technique and therefore seems banal. Other devices now outmoded or disused are obtrusive and irritating—the time-lapse fades within single scenes, the low comedy relief, the shots of blossoms and domestic animals interjected for sentiment's sake. The extremely improbable plot creaks loudly and the musical score, added when the film was re-released in the early days of sound synchronization, seems almost as dated at the Victorian morality. Yet if most of the characterizations are two-dimensional, they are handled with vigor and skill and the study of Anna is entire and convincing. Miss Gish conveys the moods and feelings of the sorely tried heroine more skillfully and with more restraint than she had done in BROKEN BLOSSOMS. Her performance is remarkable for its range, apparent spontaneity and sincerity: it could be contrasted with many contemporary performances to her advantage. Scenes such as the baptism of the dying baby, and those in which Anna hears Sanderson confess the mock marriage and David Bartlett declare his love, are almost as effective today as they were twenty years ago. The flight through the storm, the ice scenes and the split-second rescue re-main triumphs of direction, camera placement and editing in which Griffith again attains, though hardly surpasses, the vitality of THE BIRTH OF A NATION and INTOLERANCE.

The period between INTOLERANCE and WAY DOWN EAST marks the apex of Griffith's success. A figure of international importance, he had played a signal part in founding a huge industry—he had already created a new art form—in which the United States became and remained supreme. Except for Frank Lloyd Wright, no such eminent American as he had arisen in the arts since Whitman. He was to continue active for another decade, though the most fruitful years were past. Already men trained under him were stepping into the limelight, at the same time that newcomers drawn from many walks of life, and from Europe as well as from this country, were likewise contributing new ideas, new techniques. Erich von Stroheim, who had been one of Griffith's assistants as well as one of his leading actors, made two films, BLIND HUSBANDS (1919) and FOOLISH WIVES (1921), which attracted wide attention and set a new style. His directorial career—culminating in the superb and somber GREED (1924)—afterwards suffered a great eclipse rendered only the more startling by his reemergence as an actor in the French film LA GRANDE ILLUSION in 1937. Frank Powell has already been referred to. Mack Sennett, even earlier, had graduated from acting and providing plots for Griffith to the glorious creation of Keystone comedies. Lowell Sherman, villain of WAY DOWN EAST, was to direct—among other films—Mae West's SHE DONE HIM WRONG (1933). Donald Crisp, after BROKEN BLOSSOMS, also became a director of distinction—Buster Keaton's THE NAVIGATOR (1924) and Douglas Fairbanks' DON Q (1925) are perhaps his best-remembered pictures and today he is again a leading character-actor. It would fill many pages to enumerate the notable actors and actresses who gained their first experience under Griffith and first faced the camera with Bitzer turning. All these fed the industry with new talent. But times and taste alike were changing. From now on Griffith's films were often criticized, even by the trade press, as "melo-

Lillian and Dorothy Gish in ORPHANS OF THE STORM, 1922.

dramatic." In 1924 James Quirk boldly admonished Griffith in an editorial in *Photoplay*: "You have made yourself an anchorite at Mamaroneck . . . your pictures shape themselves towards a certain brutality because of this austerity . . . your refusal to face the world is making you more and more a sentimentalist. You see passion in terms of cooing doves or the falling of a rose petal . . . your lack of contact with life makes you deficient in humor. In other words, your splendid unsophistication is a menace to you—and to pictures."

ORPHANS OF THE STORM

But in ORPHANS OF THE STORM (1921), and again despite an old-fashioned story, Griffith's ability to individualize characters, handle crowds and sustain suspense stood him in good stead. The film was liked by the public. Lillian and Dorothy Gish again scored a triumph, while Monte Blue and Joseph Schildkraut won innumerable admirers. Even today, despite such minor irritations as the silly subtitles and the awkward (if traditional) staring and groping of the blind girl, this film can grip one's attention. That cannot be said of his next picture, THE WHITE ROSE (1923), yet in 1922 it was Griffith who had once and for all set the pattern for the murder-mystery film in ONE EXCITING NIGHT. And his next two pictures

were still notable for the emotion they had the power to conjure up, for the splendor of their photography and for their scope and boldness. AMERICA (1924) was not another BIRTH OF A NATION but it was a film which few other directors at that time would have attempted. ISN'T LIFE WONDERFUL, also 1924, is a little masterpiece. Here we have the curious spectacle of seeing the man who had made the anti-German and violent HEARTS OF THE WORLD now produce a sensitive and often touching pro-German picture which most forcibly conjures up the tragedy of defeat and hunger in Central Europe. ISN'T LIFE WONDERFUL lacks the shock-value of the more powerful scenes in Pabst's THE JOYLESS STREET, made the following year and treating a similar subject, but it bears comparison with it, though the American film—much of it shot in Germany—was the late product of an old master while THE JOYLESS STREET was the second film of a new one. Among all Griffith's later pictures this one wears best.

It was to be his last independent production for some time to come and, if one were to write of him only in terms of the adulation he and his career as a whole command, then a review of his extraordinary achievements might best end here. From this time on he was to work usually under conditions ill-suited to his temperament and experience, while business and financial problems of increasing complexity beset him.

Made in Germany in 1924, ISN'T LIFE WONDERFUL was the first film to dramatize the tragedies of defeat and hunger in Central Europe.

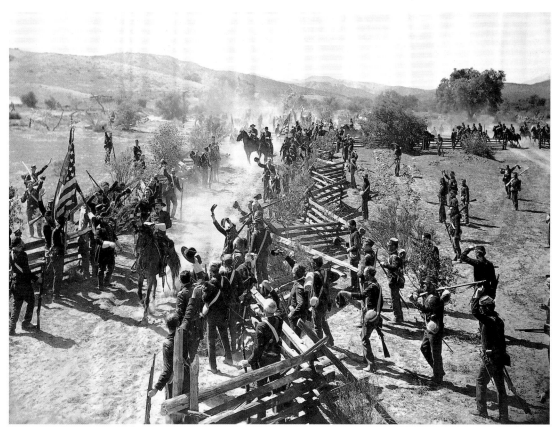

ABRAHAM LINCOLN, 1930. United Artists.

At the age of fifty, when he had already directed hundreds of films which include the most profoundly original films ever made, he was placed in competition with much younger men who inherited ready-made the technique he had perfected through arduous years. Obviously they were far better able than he to adopt new methods, to adapt themselves to changing tastes and to represent the post-war age.

There is nothing surprising in the fact that Mr. Griffith, during this period on contract to Famous Players-Lasky, grew less than himself. In our own time many of the more gifted film-makers chafe continually under studio conditions and long to work independently—as Griffith originally did. In 1925 he had been his own master for too long to submit easily or fruitfully to control. But the burden of motion picture financing and distribution forced him of necessity into the service of a large corporation. The results were painful and costly to him, and the films were not excellent. It would be only just to recall that, under far less hampering conditions, artists in other media—Monet and Tennyson, for example—have at comparable stages in their careers also entered upon a period of decline.

GRIFFITH AND THE TALKIES

Nevertheless, with his next independent production, ABRAHAM LINCOLN (1930), it looked as though the master were back into his stride. The industry had undergone a severe shaking up with the advent of sound in 1927 and the time was propitious for the "come-back" of an old-timer. The sound-film with Walter Huston in the title role was hailed as "a Griffith achievement" and, when the votes were taken early in 1931 for the best director of 1930, it was

Griffith who won the distinction. For a man who had been making films continuously since 1907 this seems an extraordinary feat. Griffith himself contends however that ABRAHAM LINCOLN would have been a much better picture had he not been compelled to make it, as he says, "all dry history with no thread of romance." But in December, 1931, his talking picture THE STRUGGLE saw the light and was much less favorably received. *The Film Daily*, for instance, wrote: "This is poor entertainment; it is an old-fashioned domestic drama with little box-office appeal." Perhaps this estimate was correct. The theme and spirit of the film were substantially those of Griffith's THE DRUNKARD'S REFORMATION of 1908, though alcoholism had become a topic of intenser interest since Prohibition. In truth THE STRUGGLE seems pedestrian and inept today, an impression rendered worse by the poor sound recording—but not in comparison with the average film of 1930. And there are some remarkable moments in it.

Were we to regard THE STRUGGLE as Mr. Griffith's swan song, this brief account of his career would seem to end on a minor air. Henceforth this great pioneer steps into the limelight only occasionally and then, alas, too often in connection with lawsuits, receiverships and the like. It seems a very long time since the Biograph days. The children who tripped to fortune up the steps of 11 East 14th Street are all of them middle-aged or dead, and "Billy" Bitzer has fallen on evil days. It is true that the sun shines on perennially youthful Lillian Gish, her sister Dorothy, and on Mary Pickford, and that Lionel Barrymore's name remains one to conjure with. It is true that Mr. Griffith himself can match for looks and sheer force of personality any man twenty years his junior—he gives an extraordinary air of enjoying life while being somewhat detached from it. He even professes to think it rather amusing, if pleasant, that anyone should bother about his old films. But ours is a very different world from the one he triumphed in; a simple story of right overcoming wrong at the last moment no longer serves as a scenario, and no one will ever create the art of the motion picture again.

Lionel Barrymore at the beginning of his screen career in FIGHTING BLOOD, 1911. F.

It is enough that Griffith *did* create it but—humanly—his story at this later stage has some bitterness in it.

There is a pleasant anecdote to conclude with. In the summer of 1936, the ace-director Willard S. Van Dyke is about to shoot some exterior crowd scenes for SAN FRANCISCO. Mobs of extras, a platoon of assistants, huge cameras and their attendant genii, sound electricians and gaffers and make-up men all mill under the California skies. Money is being spent here. On to the set strolls D. W. Griffith, a distinguished visitor. Twenty years before Van Dyke had been one of the assistants on THE BIRTH OF A NATION, and he is not the sort of man who for-

Griffith in 1936: a publicity picture inscribed: "To D. W. my former boss and unsuspecting teacher" by the ace-director, W. S. Van Dyke

gets. After mutual greetings, Van Dyke asks Griffith if he will take over the direction, and Griffith consents "just for fun." And so part of the memorable scene of mass action in SAN FRANCISCO where principals and extras climb the hill, was made not only by Van Dyke but by "old Colonel Jacob Griffith's son," who had set out from Louisville so many years earlier to seek fame and fortune. He had won both, though not in the direction he then anticipated; had seen both recede, though gently and partially from him. But the men who make films today know who it was that taught them the basis of their craft. The American public, which for forty-five years has so keenly enjoyed and supported the motion picture, has been somewhat reluctant to allow it the status of an art. Now, gradually, they too are recognizing that in Griffith they have one of the greatest and most original artists of our time.

IRIS BARRY

A NOTE ON THE PHOTOGRAPHY OF GRIFFITH'S FILMS

When Griffith joined Biograph he was fortunate to find in the studio G. W. Bitzer, who had been with the company since 1896, first as electrician, but soon as a jack-of-all-trades—cameraman, property man, scenic designer and director. The two at once became companions, and for sixteen years Bitzer almost single-handedly realized on film the action that Griffith directed. They worked together so closely that it is virtually impossible to separate their technical contributions. Bitzer's mechanical ingenuity made possible some of Griffith's most revolutionary ideas. On the other hand many of the devices which Griffith used with great effect came about almost accidentally through Bitzer's constant experiments to master the primitive technique of the day.

The Mutograph camera used by Biograph in the early 1900's was a clumsy instrument. One of its great drawbacks was that film could not be re-rolled for a double exposure. This meant that the company could not make trick films, which were then very popular. Perhaps this purely mechanical deficiency of equipment made Griffith's ideas particularly attractive to the Biograph financiers, for it offered them a way to meet competition through novelty. Bitzer recollects that this camera was used for a long time in the Biograph studio. It could be driven by hand or by a motor. Raw film, without the familiar marginal perforations of today, was put into the camera; during the shooting two holes per frame were punched out, and the celluloid disks fell through the bottom of the camera case onto the ground in a steady stream. Bitzer could easily duplicate a camera set-up by putting his tripod over the little pile of celluloid disks. Static electricity, generated by the friction feed of the film, caused trouble; to overcome it the interior of the camera was heated with a shielded bicycle lamp which burned alcohol. But in cold weather, when static was most severe, the heat brought further trouble: condensation on the lens. The film

34

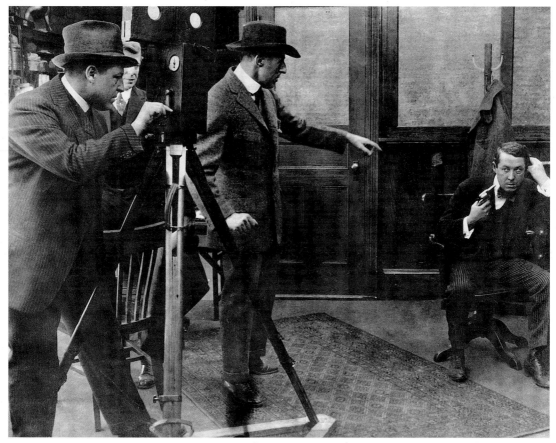
Bitzer at the camera, Griffith directing Henry B. Walthall in THE ESCAPE, 1913.

scratched easily, and these scratches showed up so prominently in sky areas that it was necessary to exclude as much sky as possible in the composition of the shots. Yet out of this crude equipment came some of the finest photography seen on the screen, and the catalog of innovations is staggering.

Many of these innovations began as accidents, which Bitzer turned into practical techniques. A less imaginative and courageous director than Griffith would have hesitated to recognize their esthetic and dramatic value. This is not the place to discuss priority; the importance of these devices lies in their functional, almost automatic origin, and in their brilliant exploitation.

Slow film which is "unbacked"—i.e., which has not been coated with an opaque light-absorbing substance on its reverse side—is prone to exaggerate highlights in a most distressing way. Points of light seem to spread and to eat up adjacent darker details. This *halation* can be partially prevented by shading the lens with a tubular hood. Photographing one day by electric light in his basement, Bitzer improvised such a lens hood from an old glue pot. The results were fine, so fine that he took his home-made gadget on location. But when the film was processed the corners of each frame appeared rounded off in darkness. Bitzer had forgotten an elementary optical fact—that the iris diaphragm in the lens which controls the amount of light falling on the film also affects the focus. Like the human eye, the iris of the camera eye is wide open in dim light, and constricted in bright light. Objects near and far are sharp when the camera iris is small. Inadvertently, by closing the camera iris to the small

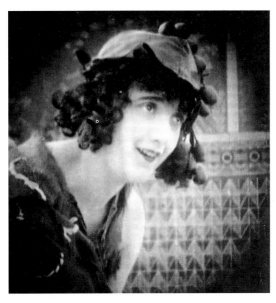

Constance Talmadge as "the little mountain girl" in
INTOLERANCE. F.

diameter demanded by brilliant sunlight, Bitzer
had brought the end of his lens hood into focus.
When Griffith saw the projected film he was far
from disappointed. "He got very excited,"
Bitzer told the writer, "and asked me how I'd
gotten the new effect. I said that I'd been work-
ing on it quietly for the last six months!"

The logical step was to contrive a lens hood

Shooting the "ride to the rescue" in the modern story of
INTOLERANCE: Bitzer at the camera, Griffith standing.

which could be adjusted to give more pro-
nounced effects. A large iris diaphragm from a
still camera was added to the hood. To adjust
it more easily a handle was fastened to the
flimsy setting. This led to another accident.
During the shooting the weight of the handle
closed the iris gradually; the dark corners of the
frame grew until the image was entirely blotted
out. Again technical failure and recognition by
Griffith of another new device: the fade-out.
"This was just what we needed," pointed out
Bitzer. "The climax of all these films was the
kiss. We couldn't linger over the embrace, for
then yokels in the audience would make cat-
calls. We couldn't cut abruptly—that would
be crude. The fade-out gave a really dignified
touch; we didn't have a five-cent movie any
more."

But the vignette mask was not always satis-
factory; it cut out part of the scene. To subdue
the corners of the frame and direct the eye
towards the principal action the gauze mask
was developed—simply a couple of layers of
black chiffon fastened over the hood with a
rubber band. Holes were burned in the gauze
with the end of a cigarette where the image
detail should be distinct. Further experiments
were made with iris diaphragms made of trans-
lucent celluloid, with graduated filters, and
with "barn doors"—a box with four sliding
members which could be pushed in at will to
change the rectangular proportions of the
frame. The front of Bitzer's camera became
notorious, and rival cameramen would bribe
actors to give them detailed reports on his
latest gadget.

It seems incredible that every foot of film in
THE BIRTH OF A NATION was ground out by one
cameraman—Bitzer—and with one camera. "It
was a $300 Pathé machine," he reminisced
"with a 3.5 2-inch lens interchangeable with a
wide-angle lens—that is you had to screw one
out and screw the other into its place. None of
your turrets like they have today, where the
cameraman presses a button and the 6-inch
lens pops into place! It was a light camera, and
it was easy to pick it up and come forward for a
close-up, back for a long shot, around for a side
angle. But there were times when I wished

36

that Mr. Griffith wouldn't depend on me so much, especially in battle scenes. After all a fellow doesn't want to spend all his time in dusty California adobe trenches. The fireworks man shooting smoke bombs over the camera—most of them exploding outside the camera range and D. W. shouting 'Lower, lower, can't you shoot those damn bombs lower?' 'We'll hit the camera man if we do,' answered the fireworks brigade, and bang!, one of them whizzed past my ear. The next one may have gone between my legs for all I knew. But the bombs were coming into the camera field so it was O.K.

"All we had was orthochromatic film. Perhaps this old stock with its limited range of tones really helped the BIRTH OF A NATION photography—it sort of dated the period not only in the battle scenes but in the historical events like Lee's surrender."

This realistic quality has often been remarked. Individual shots have been compared to Brady's Civil War photographs. The similarity is not accidental, for Bitzer, bribing a librarian with a box of chocolates, got hold of some photographic copies of the famous Civil War series for Griffith's use. Besides the quality of the slow orthochromatic film, light played a very important part in the picture. Daylight was used exclusively in THE BIRTH OF A NATION, except in the night shots lighted by flares. Throughout his career Bitzer has used daring lighting, even to the extreme of allowing light to fall directly on the lens. Reflectors were used to soften shadows, bringing out their detail, but always in a subdued way so that their presence is unnoticed in the film. These reflectors were "soft" —they were of cloth, not casting the harsh light of a polished metal, tinfoil or other "hard" reflector. Bitzer likes to tell about how he stumbled on back, or reverse, lighting. During a lunch hour on Fort Lee location he playfully turned his lens on Mary Pickford and Owen Moore as they were eating sandwiches, and ground out a few feet of film without their knowledge. The two were between the camera and the sun, but Bitzer went ahead—after all, the sequence was intended only as a joke, to liven up the projection room audience. Enough light happened to be reflected into their faces to hold the detail, and when it was screened Griffith was more than amused: it indicated a new approach to lighting.

During the last twenty-five years the scope of cinematography has broadened enormously. Bitzer's experiments have been universally adopted and refined. Yet, looking back at the photographic beauty of the epic Griffith-Bitzer films, one is amazed that the quality of cinematography has not kept pace with its technical growth. Bitzer's pioneer achievements rank among the most remarkable and significant in film history.

BEAUMONT NEWHALL

CHRONOLOGY

The names of films are in capital letters; those of plays and books in italics. A complete list of Griffith's hundreds of films, and much additional material, may be consulted at the Film Library of the Museum of Modern Art.

1875 *Jan.?* David Wark Griffith born at Crestwood, Oldham County, Kentucky.

1897-99: Plays supporting roles with the Meffert Stock Company, Temple Theatre, Louisville.

1900-03: Acts with a number of touring companies.

1904: Small roles in *Trilby* and *East Lynne* with Ada Gray's company on her farewell tour.

With the Neill Alhambra Stock Company as Abraham Lincoln in *The Ensign* in Chicago.

1905: With the Melbourne MacDowell Company in *Fedora*.

1906: With Nance O'Neill's company on tour in *Elizabeth, Queen of England, Rosmersholm* and *Magda*.

Marries Linda Arvidson Johnson in Boston.

1907: James K. Hackett pays him $1,000 advance royalties on his play *A Fool and a Girl* which is produced in Washington on September 30th with Fanny Ward as the star.

Engaged by Edwin S. Porter to play the leading role in a film RESCUED FROM AN EAGLE'S NEST for the Edison Company.

1908: Sells several stories to Wallace McCutcheon at the Biograph Company and acts in Biograph films.

Directs THE ADVENTURES OF DOLLIE for Biograph and henceforward makes one long and one short film a week for this company.

Aug. 17: Signs a contract with Biograph at $50 a week plus guaranteed commission of not less than $50.

Aug.: Demands a change of camera set-up in mid-scene in FOR LOVE OF GOLD.

Sept.: Gives Mack Sennett his first important role in FATHER GETS IN THE GAME.

Oct.: Introduces a flash-back in AFTER MANY YEARS.

1909
Jan.: Contrives with Bitzer an effect of light and shade in EDGAR ALLAN POE.

Mar.: Contrives with Bitzer a firelight effect at the end of A DRUNKARD'S REFORMATION.

May: Engages Mary Pickford, who plays small roles in WHAT DRINK DID and THE LONELY VILLA.

Introduces cross-cutting to create suspense in THE LONELY VILLA.

Dec.: Griffith and his company leave for California where they winter this and subsequent years.

1910 *May:* Introduces a long-shot into RAMONA. He is also moving the camera much closer to the actors for scenes of intimate action.

1911
Mar.: Speeds editing and cross-cutting in THE LONEDALE OPERATOR to intensify suspense, and introduces very close shots.

May: Insists on making ENOCH ARDEN in two reels which, however, are released separately.

June: Lionel Barrymore joins the company.

1912 *Aug.:* Lillian and Dorothy Gish make their screen debut in AN UNSEEN ENEMY.

1913: Makes JUDITH OF BETHULIA, the first American four-reeler. Almost full close-ups are used.

Oct.: Severs his connection with Biograph and signs up with Mutual Film Corp., taking with him most of his actors and Billy Bitzer, his ace cameraman.

Dec.: THE BATTLE OF THE SEXES.

1914
Jan.: THE ESCAPE.

Mar.: HOME SWEET HOME.

Aug.: THE AVENGING CONSCIENCE.

At work on THE CLANSMAN.

1915
Jan.: At work on THE MOTHER AND THE LAW.

Feb.: THE CLANSMAN opens at Clune's Auditorium, Los Angeles.

At a special showing of THE CLANSMAN in New York, Thomas Dixon suggests it be called THE BIRTH OF A NATION.

Mar.: THE BIRTH OF A NATION opens at the Liberty Theatre, New York, at $2 top.

June: Adds three parallel stories to THE MOTHER AND THE LAW to make INTOLERANCE.

July: Joins the Triangle Film Corp. as star-director together with Thomas H. Ince and Mack Sennett. The firm engages many stage celebrities—Douglas Fairbanks, William S. Hart, Sir Herbert Beerbohm Tree, etc.

1916 *Sept.:* INTOLERANCE opens in New York.

1917 *Mar.:* Griffith, invited by the British Government to make a propaganda film for the Allies, sails for Europe with Lillian and Mrs. Gish.

Makes HEARTS OF THE WORLD in France and in England, returning in October.

1918: HEARTS OF THE WORLD.

1919
Feb.: Mary Pickford, Douglas Fairbanks, Charlie Chaplin and D. W. Griffith form a distribution company, United Artists.

May: BROKEN BLOSSOMS.

Sept.: Moves production headquarters to Mamaroneck, N. Y.

Dec.: Griffith and his company reported lost at sea en route for the Bahamas, but arrive after 3 1/2 days without food and water.

1920
Mar.: THE IDOL DANCER.

June: Lillian Gish leaves Griffith's company.

Aug.: WAY DOWN EAST.

THE LOVE FLOWER.

1921
Apr.: DREAM STREET.

Dec.: ORPHANS OF THE STORM.

1922 *Oct.:* ONE EXCITING NIGHT.

1923: THE WHITE ROSE.

1924: AMERICA.

Sails with his company for Germany to make ISN'T LIFE WONDERFUL.

1925: SALLY OF THE SAWDUST.

1926: THAT ROYLE GIRL.

SORROWS OF SATAN.

1928: DRUMS OF LOVE.

THE BATTLE OF THE SEXES.

1929: LADY OF THE PAVEMENTS.

1930: ABRAHAM LINCOLN.

1931: THE STRUGGLE.

INDEX

The names of films are in capital letters; those of plays and books in italics. A complete list of Griffith's hundreds of films, and much additional material, may be consulted at the Film Library of the Museum of Modern Art.

EIGHT THOUSAND COPIES OF THIS BOOK WERE PRINTED FOR THE TRUSTEES OF THE MUSEUM OF MODERN ART BY THE PLANTIN PRESS, NEW YORK, NOVEMBER, 1940.